Paul Cézanne

How he Amazed the World

Prestel

Take your hat off to Monsieur Cézanne!

Throughout his life, Paul Cézanne painted lots of self-portraits wearing an assortment of hats and caps and even a white turban.

He is now one of the most famous painters in the world although he spent most of his life out of the limelight near his hometown, Aix-en-Provence, in the south of France.

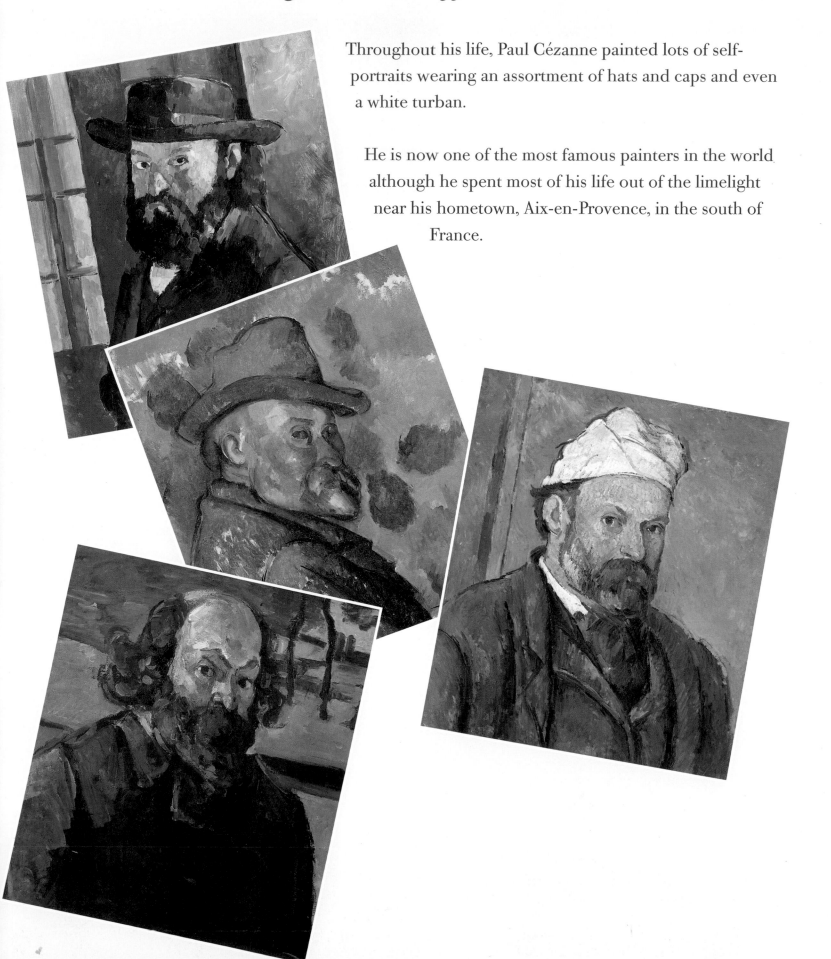

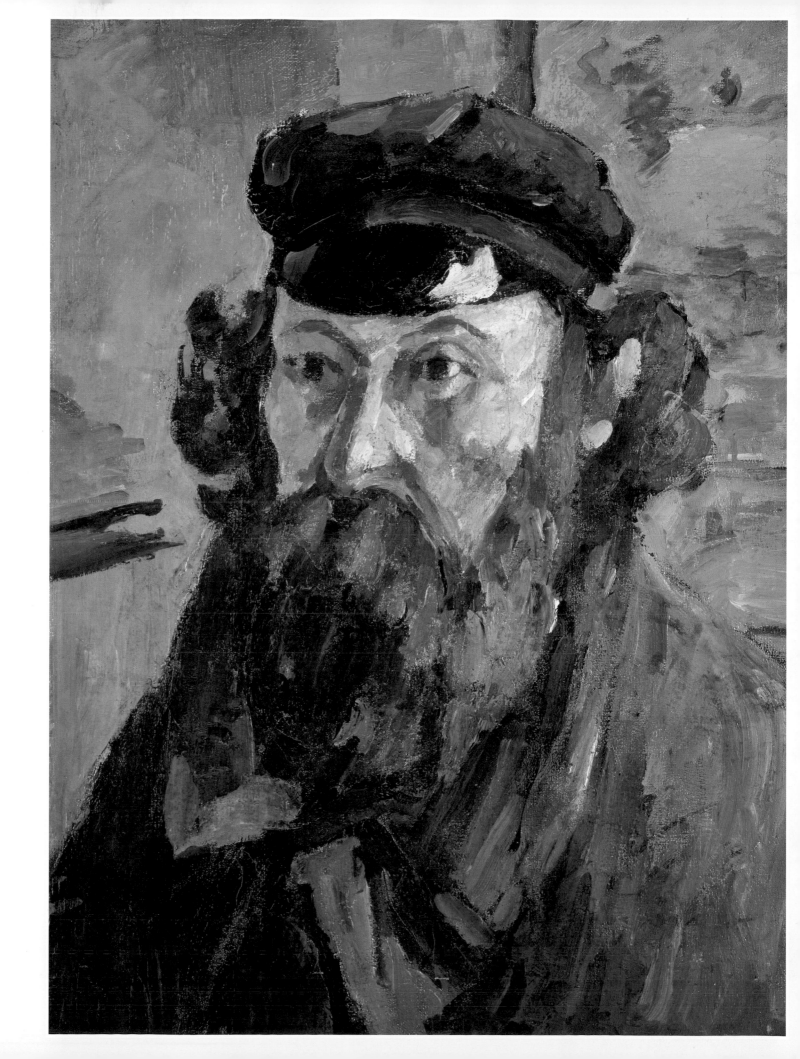

3

"I could go on painting for a hundred years ..."

Paul Cézanne liked to be on his own and loved painting above all else. But actually, he could have had a very comfortable life if he had listened to his father. **Louis-Auguste Cézanne had big plans for his son, who was born on 19 January 1839.** He had a hat shop and became so rich that, by 1848, he was able to buy the only bank in his hometown, Aix-en-Provence, in the south of France. Of course, he wanted his son to take over the family firm, so he was appalled when Paul – who had started taking painting lessons as a young boy – wanted to study painting in Paris after leaving school. His father warned him, saying: **"Think of the future. As a genius you can only die, but with money you can buy food."**

From the very beginning, Paul Cézanne worried if he was good enough. Perhaps he wasn't really talented – perhaps he wasn't a genius after all! And so he responded to his father's wishes and began to **study law in Aix**.

Cézanne's best friend, **Emile Zola**, who later became a famous writer, had been living in the French capital for quite a while. **He tried to persuade Cézanne to follow him**, and he even drew up plans for his work schedule: **"From 6 to 11 you will be at a studio doing life studies, then you will go and**

Cézanne's law lectures can't have been very interesting. Here he stopped taking notes and started to draw instead.

Paul Cézanne at the age of 22

One of Cézanne's greatest wishes was for his father to recognise him as a painter. This is a portrait of the artist's father, Louis-Auguste Cézanne, reading a newspaper. The artist has even included one of his own paintings in the background.

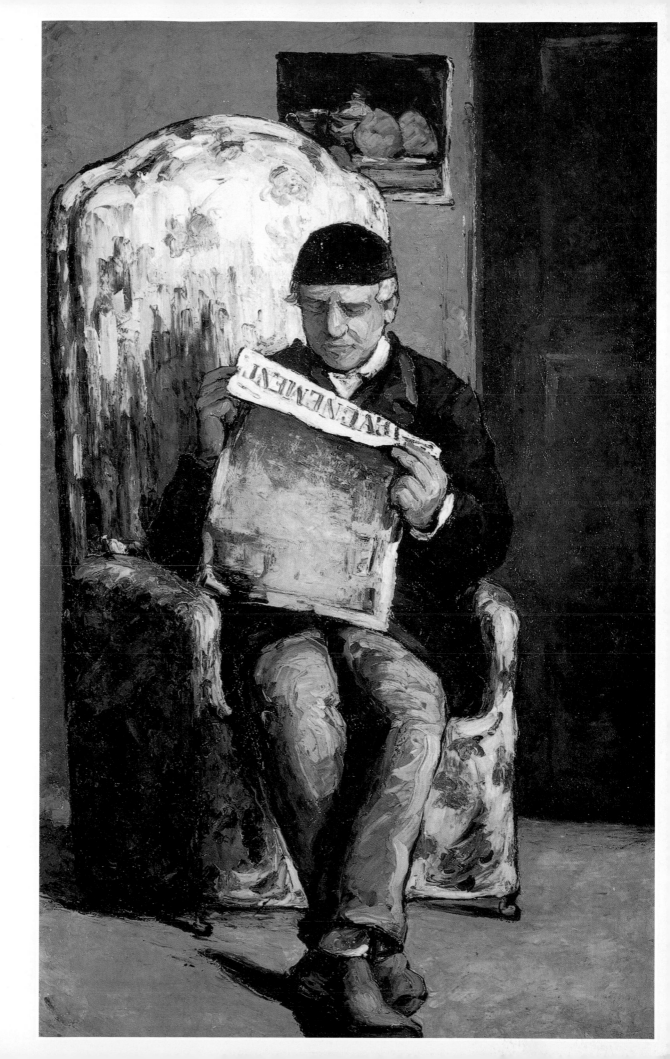

have lunch, and from 12 to 4 you will sketch paintings in the Louvre or the Musée de Luxembourg – a total of 9 hours work."

In the end, Paul was determined to leave. He refused to speak to his father until he was finally allowed to depart for Paris in April 1861. But although he was overjoyed to see his friend again and to be able to dedicate himself to his art, he didn't feel at home in such a big city. And when he failed the entrance examination to the art academy, **he was very disheartened** and went back home. There was nothing for it but to work in his father's bank! But that was almost more boring than studying law.

After one year he could stand it no longer and returned to Paris. **This time, his decision was final.** Although the art academy refused him a second time, he took drawing and painting classes at a private school and studied the Old Masters in the Louvre. Most importantly, **he got to know other artists who were also mad about painting**. At that time, they were still unknown painters and were not allowed to take part in the big annual art exhibition, the 'Salon'. Later on, as **Impressionists**, they became much more famous than the artists who had been allowed to show their works. Cézanne found that he could talk to them about art for days on end. **But despite his exciting life in the city, he always felt very close to his hometown. "And don't think that I'll ever become a Parisian,"** he wrote to a friend.

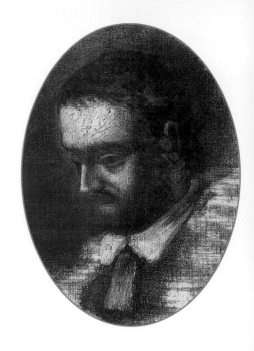

Emile Zola and Paul Cézanne grew up together as children and were close friends.

Cézanne's father bought this country house called Jas de Bouffan in 1859 and this is where Paul liked working most. He often painted the manor house with its outbuildings, pond and tall chestnut trees. This was Cézanne's favourite retreat for forty years.

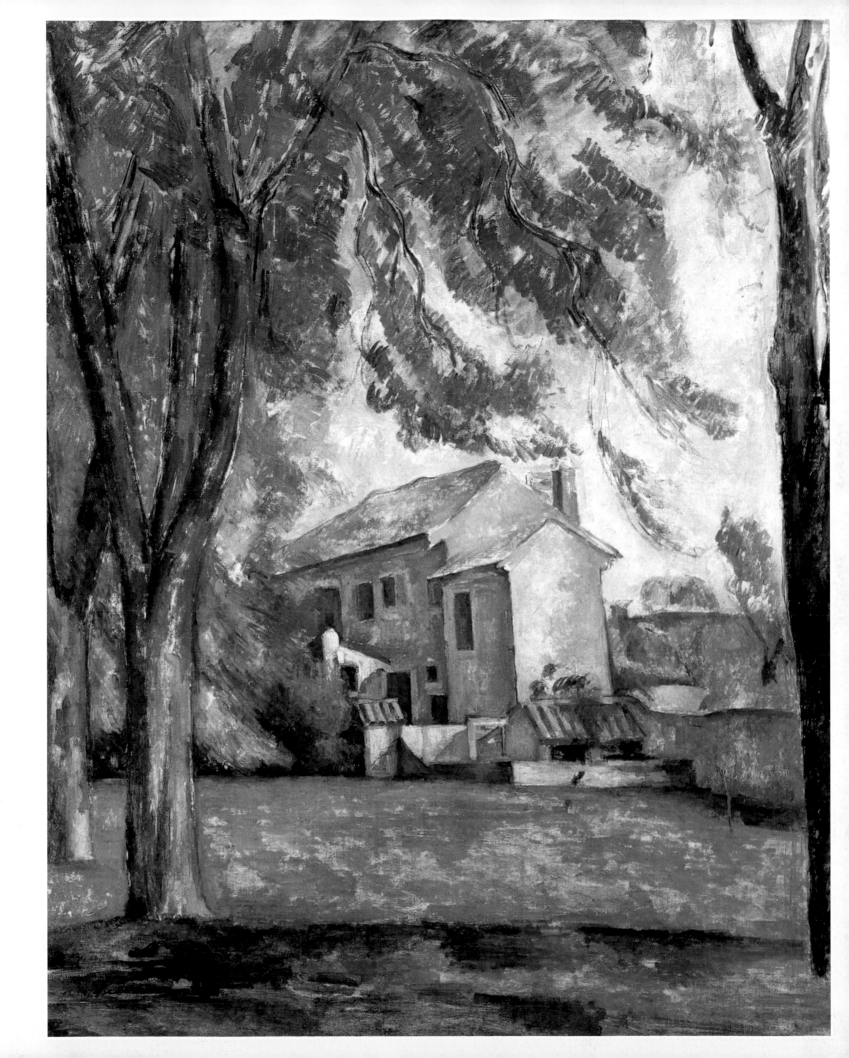

From 1864 onwards, Cézanne lived in both Paris and Aix, where he spent a few months of each year at the family's country house, **Jas de Bouffan**. In 1869 the painter fell in love with **Hortense Fiquet**, a bookbinder and, three years later, they had a son also called **Paul**. Cézanne didn't tell his father because he didn't want to make him angry or lose the money he received – money which he now really needed to support his family.

Little Paul was fourteen by the time his parents married and Louis-Auguste Cézanne was then told about his grandson. Shortly afterwards, he died, and **Paul Cézanne inherited a small fortune**. Suddenly, he no longer had to appeal to Parisian taste or push his paintings. Now he could put aside his financial worries and dedicate himself to his own style of painting.

In 1886, he broke off his friendship with Zola. The author had published a novel whose main character was a painter who never became famous and who always doubted his talent. When he read the book, Cézanne recognised some of his own characteristics and was extremely upset.

Following the death of his mother in 1897, Cézanne was forced to sell Jas de Bouffan but he didn't want to leave the area. In 1901 he bought a piece of land **in Les Lauves on a hill north of Aix** where he built a house and studio. **"I was born here and this is where I shall die."**

Paul Cézanne junior. Who does he take after – his mother or father?

Paul Cézanne aged about 36

Being a painter's model was very tiring! Cézanne's wife had to sit for hours until this portrait was finished.

Paul Cézanne painted many things in a different way to how they really are. But even so, he still managed to keep an even balance. If you look carefully, you can see shapes or patterns repeating themselves in different parts of the picture. The folds in the heavy curtain can also be seen in the skirt over Madame Cézanne's right knee. The roses in her hands are also part of the pattern of the curtain, and the shape of the frame can be found again in the back of the seat …

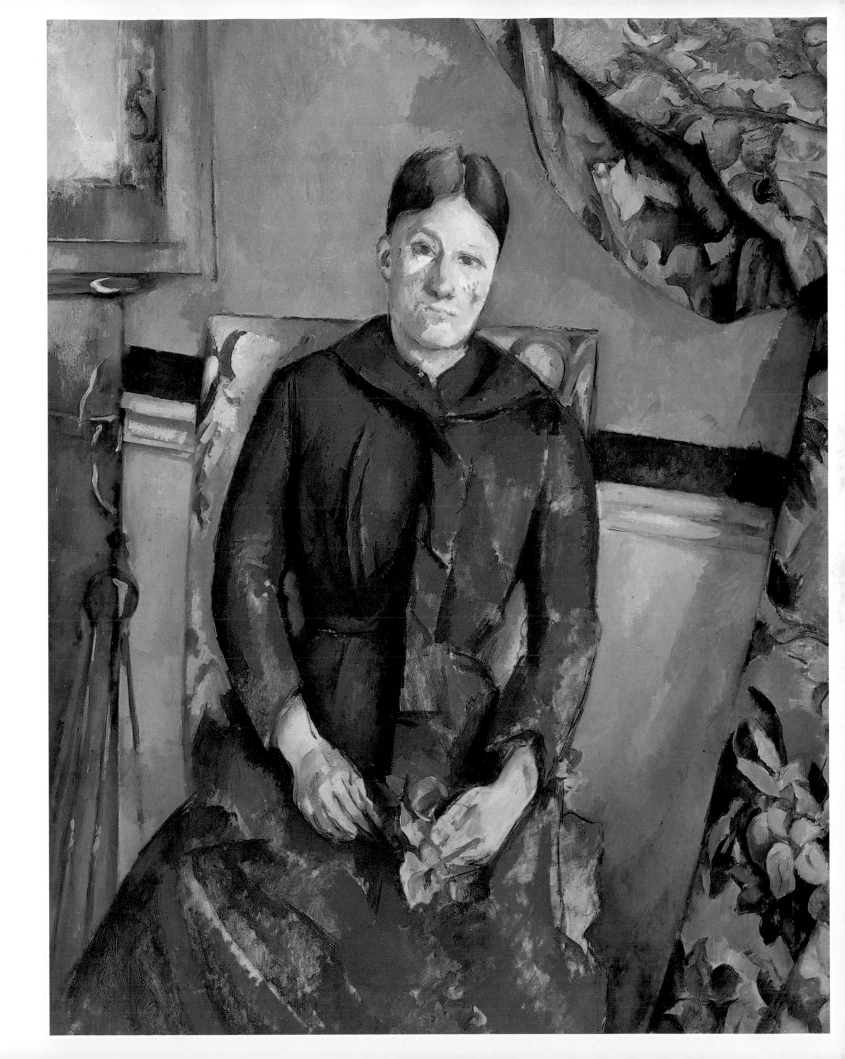

9

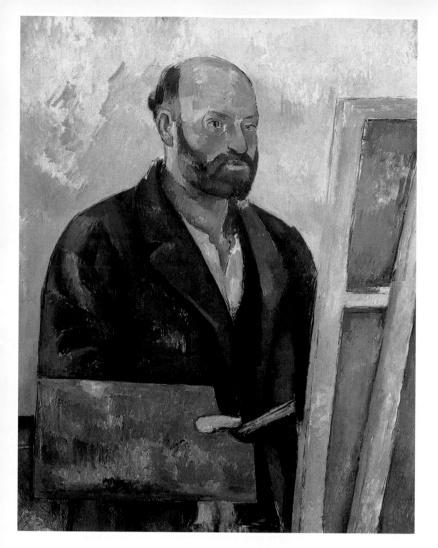

What was Cézanne painting here?

Before Paul Cézanne could start painting, he had to prepare everything carefully. First, the canvas had to be stretched over a wooden frame, like the one you can see in this picture. A crossbar helped keep its shape. Then the brown canvas was painted with a special solution to close all the pores. Finally, it often received a coating of white paint so that the colours would not be soaked up too much by the cloth. The coloured paint also showed up better against a white background.

"Just a small blob of green is enough to give us the impression of a landscape."

Cézanne put one brush of colour on the canvas after another. In the end there were so many brush-strokes that you couldn't see the white background any more and it was only then that you could actually see what he was painting.

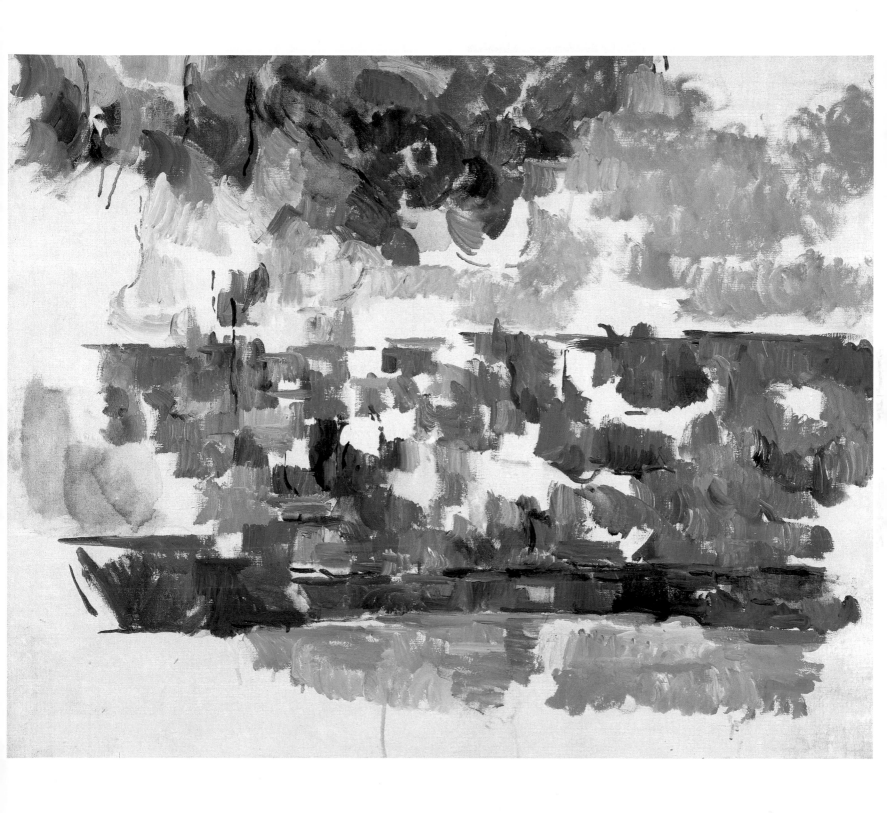

This picture was never completed.

What do you think he wanted to show?

11

Painting outdoors

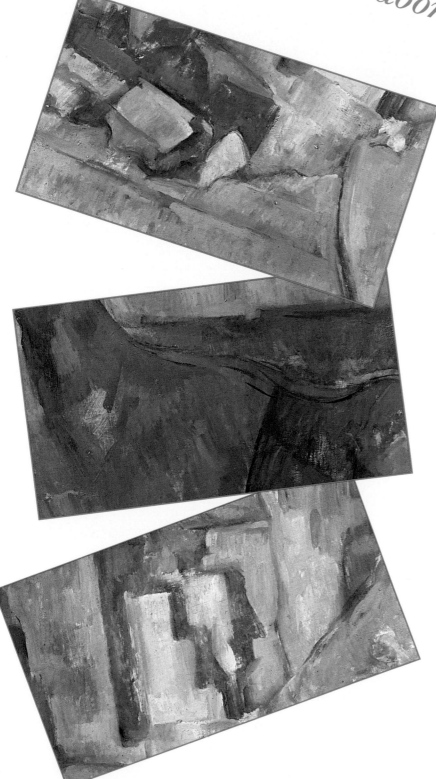

This photograph, by an unknown photographer, shows Cézanne setting off on a painting expedition in the countryside. He is carrying all his equipment on his back, including an easel, canvases, brushes and paints.

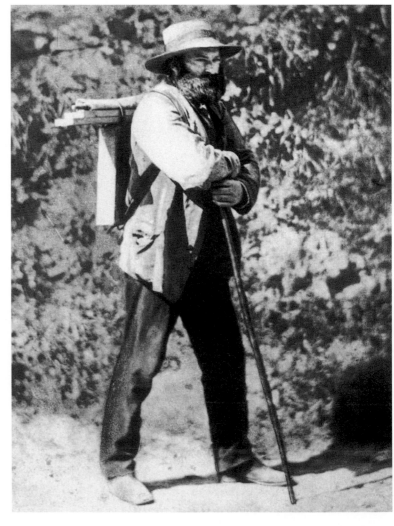

Can you find these shapes in the picture opposite?

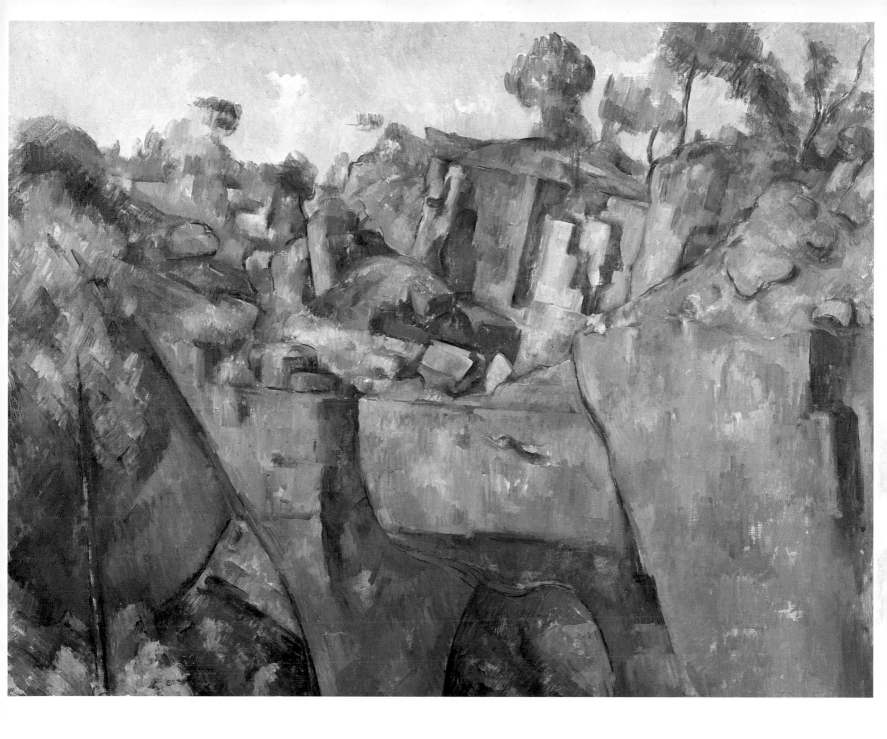

The pine forests, the fields and the hills which surrounded Aix provided Cézanne with a lot of inspiration. Often he packed everything he needed and set off to work in the countryside. Whenever he found a good motif, he painted it again and again in many different ways.

The strange shape of the rocky cliffs in the quarry at Bibémus are the result of blasting and the effects of the wind, rain and frost. In his pictures, Cézanne always tried to simplify the shape of things and to use squares or triangles. These piles of stone blocks and cubes must have made a very deep impression on him.

Beautiful views

Cézanne's youngest sister Rose lived with her husband in a big house in the country called 'Bellevue' – which means 'beautiful view' – not far from the town of Aix. The tall pine tree in this painting grew in their garden. Sometimes Cézanne would sit here for weeks on end, from morning till night, painting the view across the valley towards his favourite mountain, Sainte-Victoire.

The large pine tree in the foreground forms a frame for the panoramic view Cézanne painted. In the distance, the mountain towers above the surrounding countryside.

In between there is a wide plane with fields and meadows, houses and trees and, on the right, a railway viaduct can be seen.

The branch of the pine tree and the top of the mountain are actually miles apart and yet they are very close to each other in the painting.

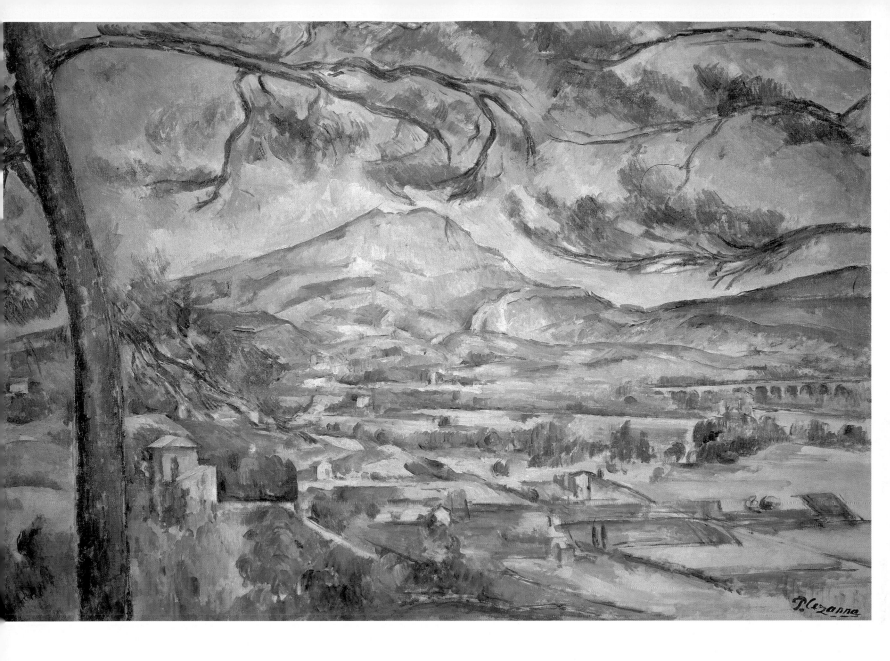

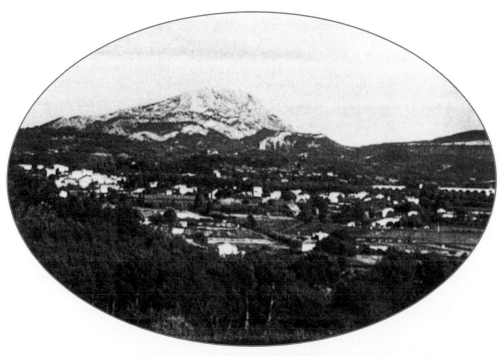

This photograph shows a similar view to that in the painting. As you can see, Cézanne didn't paint the contours of the mountain that precisely. After all, he was a painter, not a photographer!

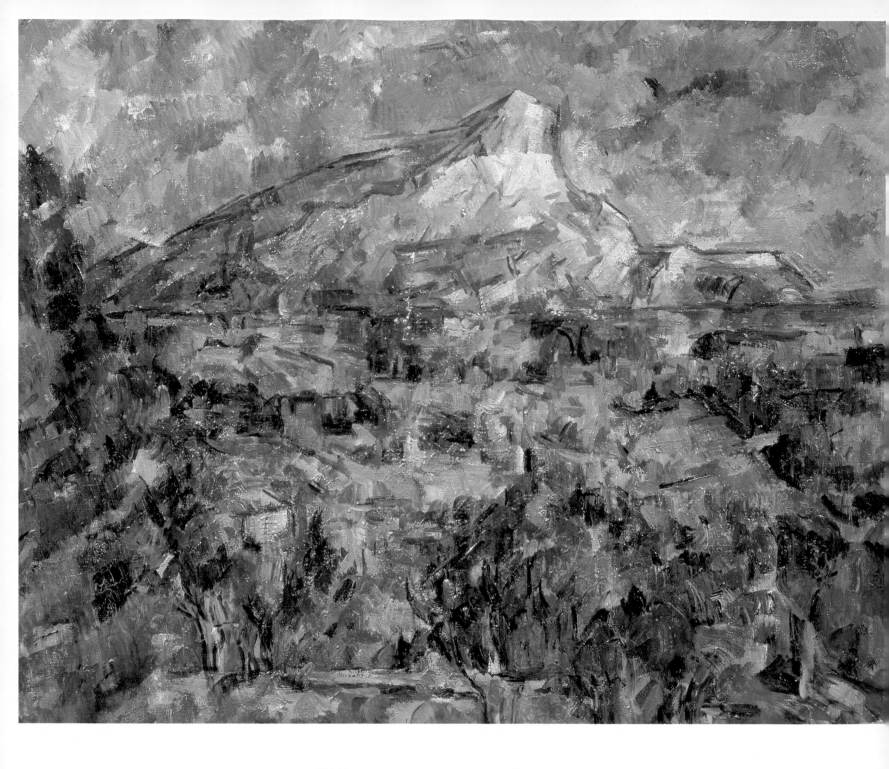

Glowing in the sun

The mountain Sainte-Victoire became one of Cézanne's favourite motifs. He painted it more than sixty times in total. The picture on the left is painted in oil and the one on the right is a watercolour. Although they both show the same scene, they are completely different. With oils you can paint very thick layers, covering up anything underneath. Watercolours are quite the opposite; they are delicate and so transparent that the paper still seems to shine through.

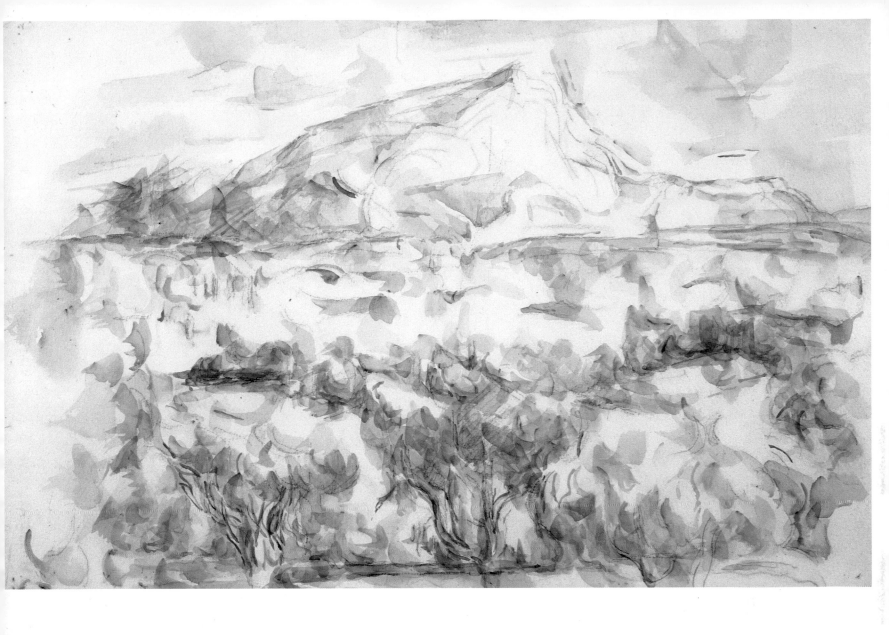

In both pictures the mountain tops and slopes immediately below glow as if the sun is shining on them.

In the oil painting Cézanne used light colours, whereas in the watercolour, unpainted areas of the paper – which produce the same effect – are still visible.

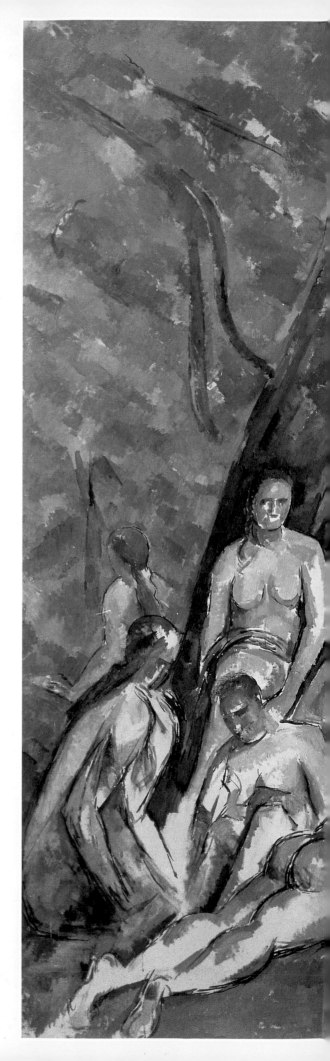

Cézanne loved swimming. When he was a boy he used to go on long swimming expeditions with Emile Zola and other friends. When he was grown-up, it was the artist's son, Paul, who would accompany him.

For many years, Cézanne painted bathing scenes such as this. Of course, he couldn't get models to come and sit by the river banks and keep still for hours on end, so he practised sketching sculptures in museums so that he could paint his figures better. But in this picture he painted the figures differently. The overall composition of the painting – the way it was put together – was more important to Cézanne than the exact portrayal of individual figures.

The artists and collectors who visited the artist in his studio in Paris and Aix were all very enthusiastic about Cézanne's huge canvases of swimming scenes. This particular painting is more than six feet tall and eight feet wide.

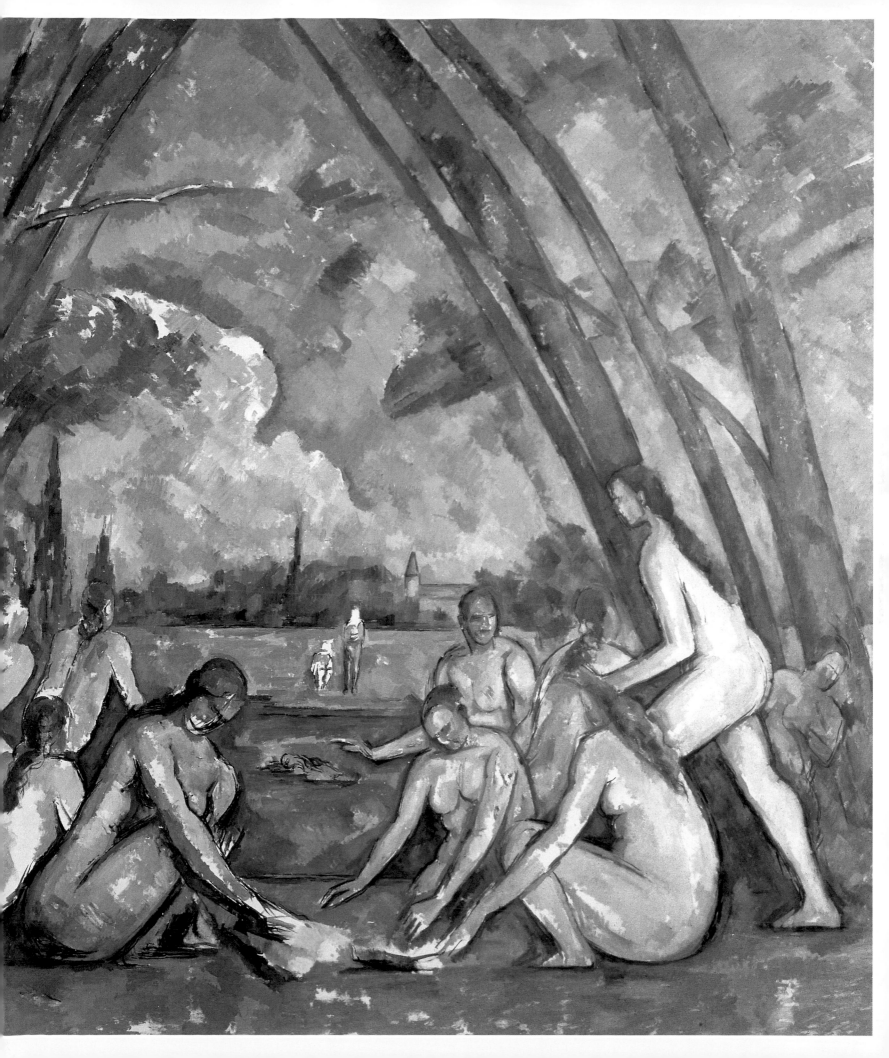

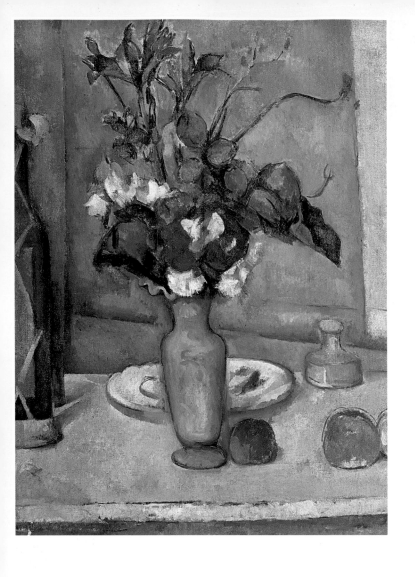

When Cézanne wasn't painting outdoors and when he had no models to paint, he arranged different objects in his studio which he then painted. These pictures are called 'still lifes'. Cézanne became famous worldwide for this sort of painting.

He was very selective about the objects he painted and positioned them very carefully before starting work. He draped tables with material and rugs, turned every apple round to its best advantage, even tilting them by putting coins underneath to keep them in the position he wanted. Although he only had a few simple objects to work with, Cézanne always managed to produce new still lifes.

He worked so slowly that the flowers often started to wither and the apples would begin to rot before he had finished painting them! He is even supposed to have used paper flowers and artificial fruit sometimes when he needed a little longer!

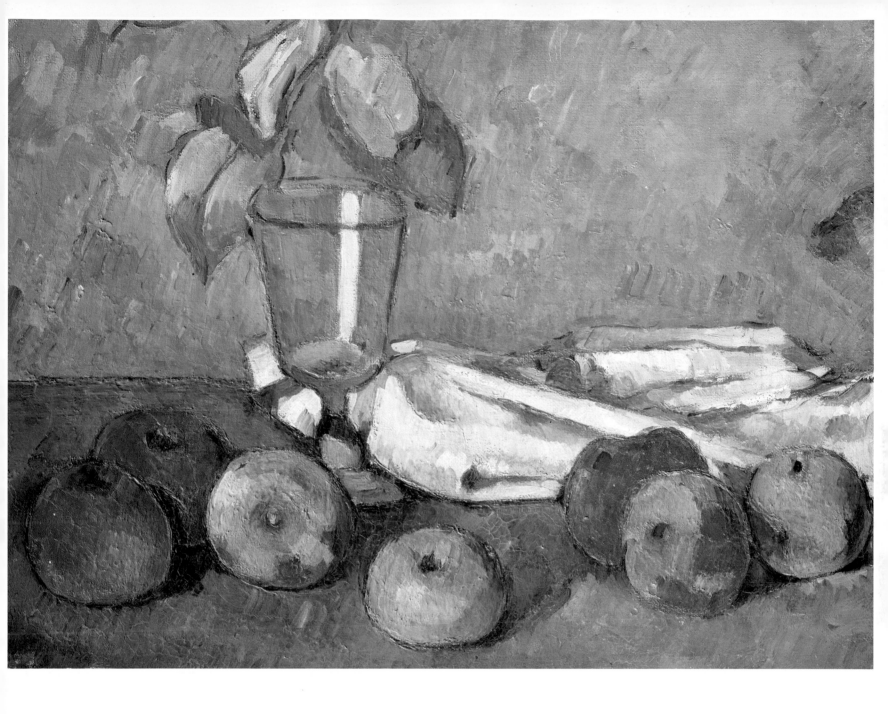

Motionless models

Look carefully at the details on the left and you will see how Cézanne painted the apples in just a few brush strokes. When standing very close to the painting, it seems as if there are just lots of blobs of paint, but moving a bit further away, the colour composition becomes clear and tasty pieces of fruit emerge.

Cézanne once said:
"I want to amaze Paris with an apple"
– and he certainly managed to do that.

Light and Shade

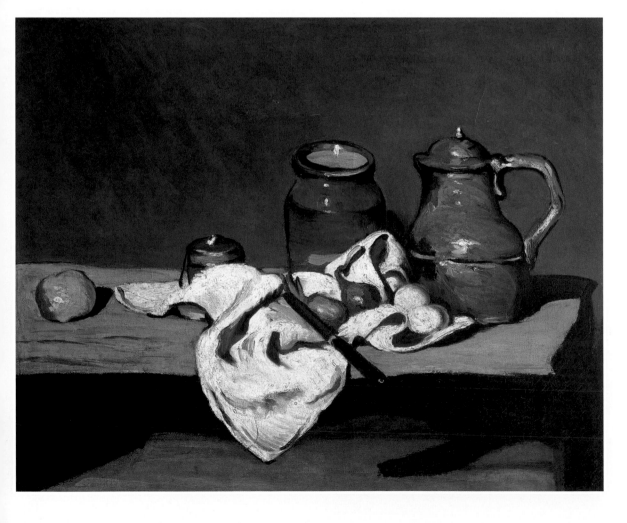

In his early still lifes Cézanne used to paint as if a bright light were shining on the objects, casting strong shadows.

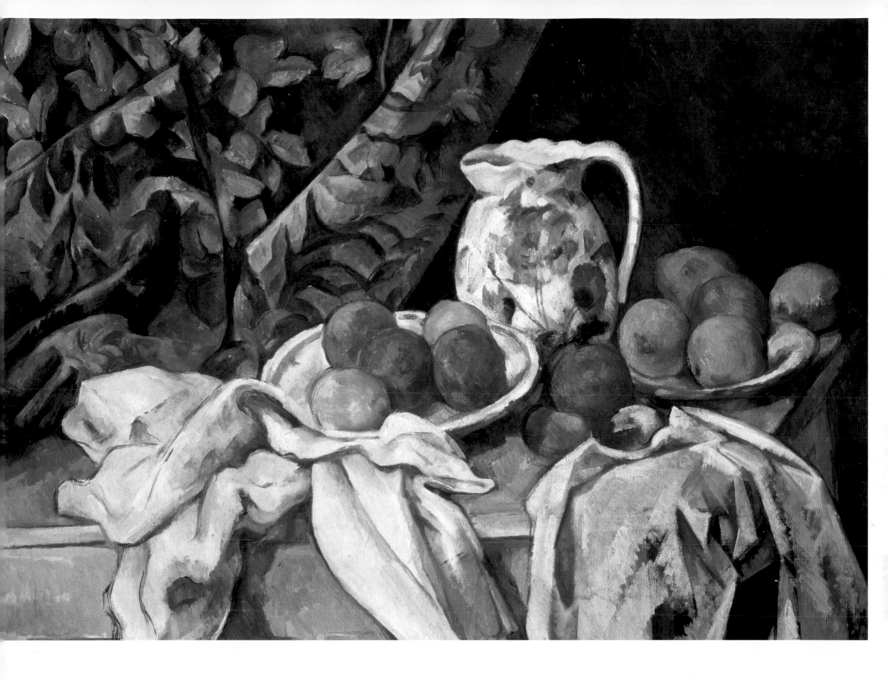

In his later pictures, on the other hand, it is the colours which seem to glow.

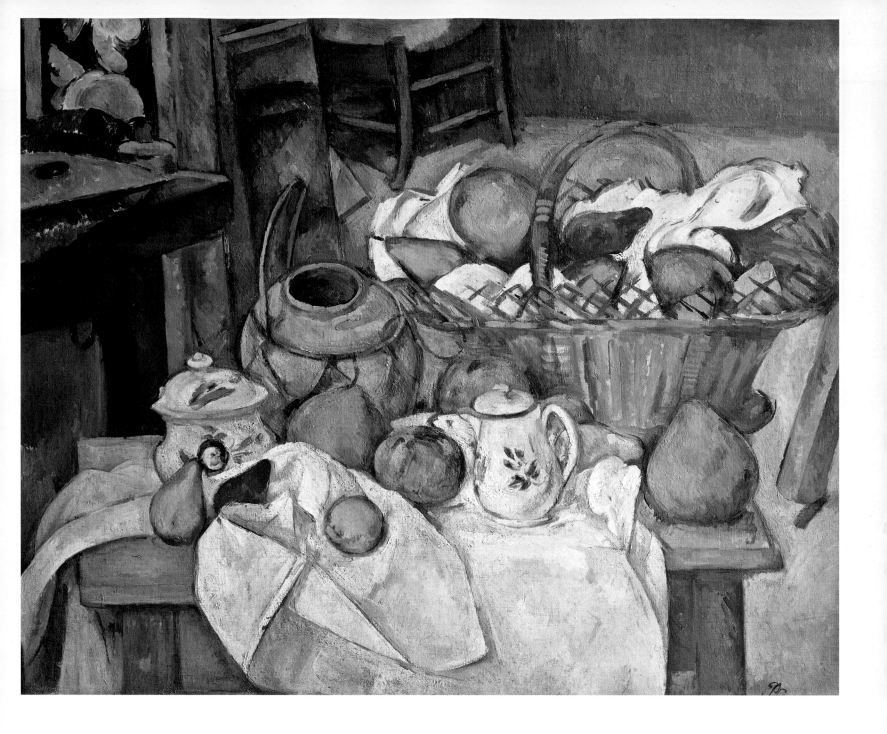

And there is something else in these pictures which
is rather confusing: Cézanne painted the different
objects from a variety of angles. We can see the jar
with the lid and the jug from the side in this still
life, whereas the fat ginger pot is shown slightly
from above.

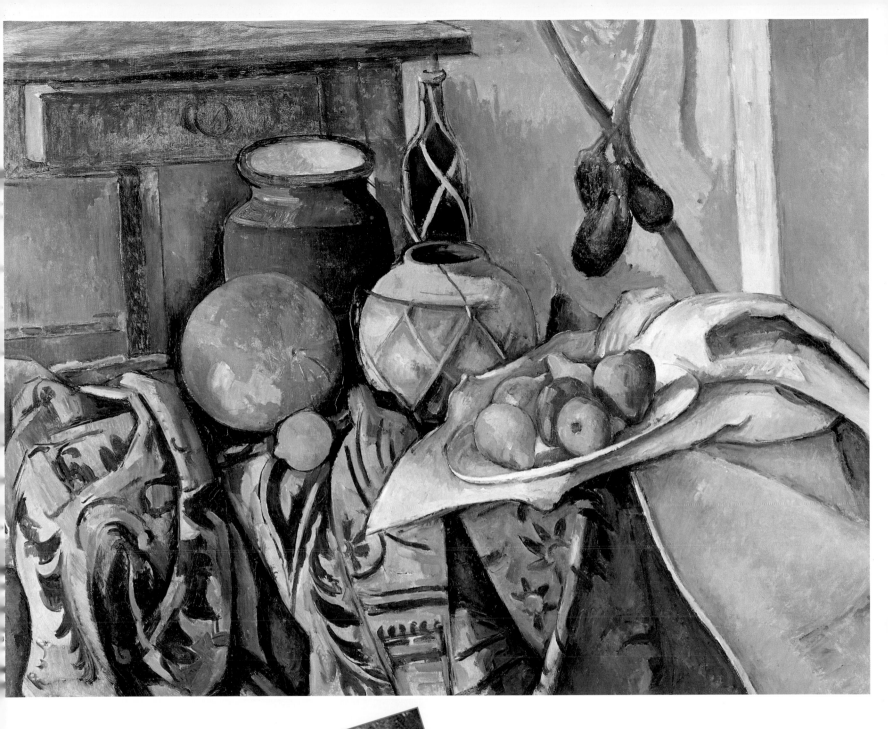

Folds of cloth hide the straight edges of the table in this picture, drawing the viewers' eyes to the apples. It even looks as if the plate is about to slide off!

Topsy-turvy table

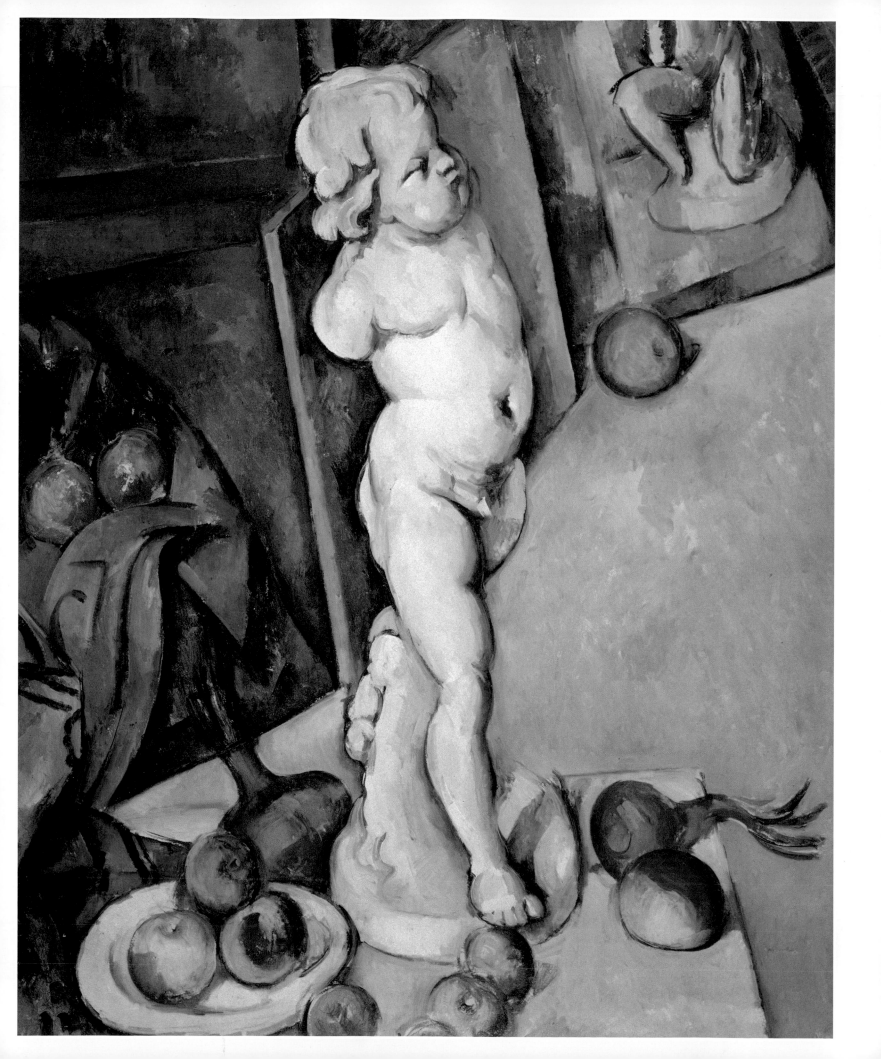

In Cézanne's studio

These photographs were taken in Cézanne's studio
long after his death. They show many of the things
he included in his paintings.

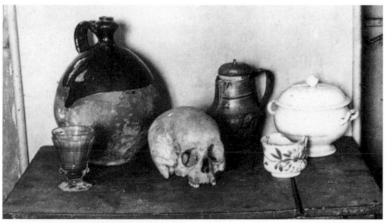

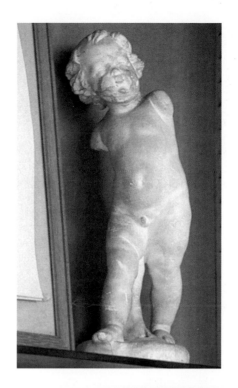

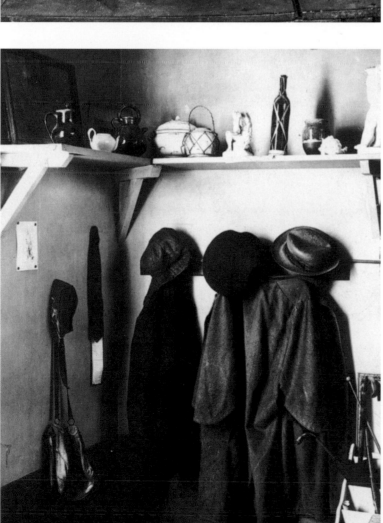

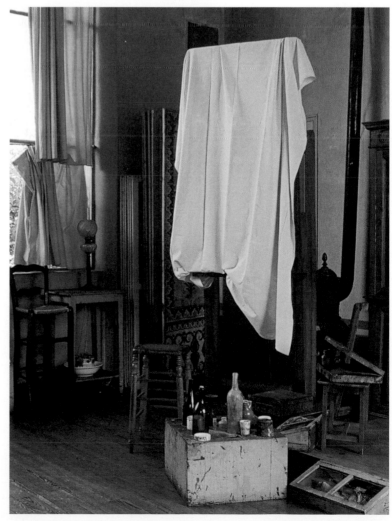

Fame at last

This man is called Ambroise Vollard. He was the first art dealer who showed any interest in Cézanne's work.

Vollard commissioned Cézanne to paint his portrait. Later, the art dealer said that he had sat for Cézanne 115 times in total over a period of several months, sometimes from eight o'clock in the morning until just before midnight. Apparently Cézanne told Vollard off for not sitting still during their very long sessions. Now and again he even fell asleep. Cézanne told him he should behave like an apple because apples never moved!

Later on, Vollard insisted that he had discovered Cézanne, although Cézanne's colleagues had long since recognised him as a great painter.

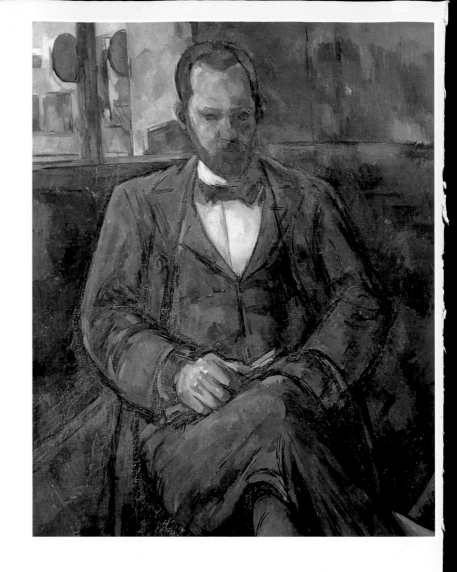

On 15 October 1906, Paul Cézanne, who was by now quite an elderly man, was painting outdoors near his studio when, quite suddenly, a very bad storm broke overhead. He slipped and fell over and lay helpless in the rain for hours before he was finally found and taken home. The next day he got up early in spite of it all to continue his painting but, after some time, he felt very weak and had to lie down again. Despite his ill-health, he still managed to write a letter to his paint supplier complaining about a late delivery. Little more than a week later Cézanne died on 23 October 1906 while working on one of his pictures.

The house in Les Lauves where Cézanne had his last studio is now a museum. Located just outside Aix-en-Provence you can still sense the atmosphere that inspired the artist and see why the famous artist liked to retreat to the relative isolation of his country home.